DATE DUE

TED Books

! *or* ?

TED Books
Simon & Schuster

New York London Toronto Sydney New Delhi

Judge

this.

CHIP KIDD

Simon & Schuster, Inc.
1230 Avenue of the Americas
New York, NY 10020

Cover and interior design by Chip Kidd
Photographs of Good's packaging by Geoff Spear

Manufactured in the United States of America

10 9 8 7 6 5 4 3 2 1

ISBN 978-1-4767-8478-6
ISBN 978-1-4767-8479-3 (ebook)

For J. D. McClatchy

All photographs by Chip Kidd,
using an iPhone 5S, unless otherwise noted.

"Early impressions are hard to eradicate
from the mind. When once wool
has been dyed purple,
who can restore it
to its previous whiteness?"
—*Saint Jerome,*
AD 331–420

"Let me make one thing perfectly clear."
—*Richard M. Nixon*

"God was always invented to explain mystery."
—*Richard P. Feynman*

So,

what is
your first
impression
of this
book?

Well, you're still reading, so it couldn't have been that bad.

Or at least it was intriguing enough.

First impressions are key to how we perceive the world, and are perceived by it. They are our introductions to everything: acquaintances, the workplace, products, experiences, retail stores, the Internet, entertainment, relationships, design. And based on our first impressions, we judge things. We can't help it. Does that sound terrible? We all heard it as children: "Don't judge by appearances." But we do, because we live in a visual culture, and our minds instantly react to what we see.

What really matters is not *that* we judge, but *how* we do so. Is it with intelligence? Empathy? Compassion?

If you consider the example of design, the "don't judge" rule doesn't even make sense. Design, by its very nature, demands to be judged when you initially encounter it, because it is supposed to solve a problem. And if that's not happening . . . that's a problem.

How many forms have you had to fill out that are needlessly complicated? How many websites have you been directed to that you can't figure out how to use? Indeed, the Web is all *about* first impressions, and the need to be able to understand content at first glance.

As a graphic designer, specifically a designer of book covers, I'd say that making a great first impression is not just my interest, it's my job. Whether it's ink on paper or pixels on a screen, a book cover is not only the face of the text, it's your primary connection to it.

But you don't need to be a designer to appreciate problem-solving: whether you are a social worker dealing with government forms, a doctor analyzing medical data, a Web coder, or even a barista trying to figure out the espresso machine, you can tell when a piece of design is working for you or not.

I've found that the two most effective and fascinating aspects of first impressions—both the ones I create and those I encounter—are at opposite ends of the spectrum: Clarity and Mystery. After more than thirty years as a practicing designer, I continue to be amazed by how these two components work, and what happens when they get mixed up or misused.

And wow, do they. Politicians can be some of the most mysterious people in the world, usually when we need them to be the clearest. And in the age of Too Much Information, we've all seen things that could benefit from a little more mystery (that family with a name that starts with a *K* comes to mind).

So let's begin with two questions. First:

When should you be clear?

That depends on the message you want to get across, and its nature. You should be clear when you need people to understand you immediately. You want others to be clear when you need vital and specific information—say, technical guidance for your computer or phone, or when you're lost and you ask someone for directions. In either case, what is needed is clarity, and when it's not there we all know the results can be very frustrating. Especially when your GPS cuts out.

A more extreme but not uncommon example is when you hear recordings of 911 calls on the news. I always think, "If I were taking the call, would I be able to understand what the situation is?" The answer varies, and of course the calls are usually made in moments of intense panic, but these are definitely situations when a person needs to be understood.

If we apply this idea to design in our everyday lives, the examples start to become, well, clear:

Highway signage. Instruction manuals. Alarm clocks. Emergency escape routes. Wedding vows.

When decoration—a pretty facade, ornamentation, elaboration—really doesn't matter at all, clarity is most needed.

Clarity is sincere, direct, reasonable, basic, honest, perfectly readable. No-nonsense.

But when it's automatically applied to everything, things can get kind of boring.

Now, let's look at the yin to this yang, and ask:

When should you be mysterious?

Ah, the allure of Mystery. And the fun of it. Or, if we're not careful, the disappointment of it. Mystery is an extremely powerful tool; just ask Gypsy Rose Lee (kids, do a Web search) or the creators of *Lost*. You should be mysterious when you want to get people's attention and hold it, when you want your audience to work harder—when, frankly, you have something to hide.

Mystery is: a puzzle that demands to be solved, a secret code you want to crack, an illusion that may not be an illusion at all, a dream you're trying to remember before it fades away.

Mystery, it must be said, can also be terrifying: phantom pain, sudden change, irrational behavior, the loss of power. The threat of the unknown.

In my own work, mystery is hugely important. I design covers for all kinds of books: fiction, nonfiction, poetry, history, memoir, essay, comics. Each demands its own visual approach. Sometimes I want the viewer to "get it" right away, but more often I want to intrigue him or her enough to investigate the book further (i.e., to open it up, begin to read it, and hopefully buy it).

Mystery, by its very nature, is much more complex than clarity, and I try to create a balance between the two.

So for the purposes of this book, I'm introducing . . .

The Mysteri-o-meter.

The field of Information Graphics has certainly progressed over the last several decades (thank you, *USA Today*, for the charts and graphs). The idea is to create a visual piece of communication that can be understood in any languange. The "Mysteri-o-meter" on the opposite page is an example of that: a simple scale that marks the balance between Clarity (**!**) and Mystery (**?**)—the former at 1, and the latter at 10—and I've applied it to all the visual examples in the book.

Note: When something is at one extreme of the scale or the other, it doesn't necessarily mean it's good or bad. As with just about everything in life, you'll have to take this caveat in context. Some examples will be frustratingly mysterious when they should be clear, and some will be all too clear when more discretion is wanted. And vice versa.

And so, let's start with the process of . . .

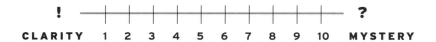

! CLARITY 1 2 3 4 5 6 7 8 9 10 MYSTERY ?

Learning to judge.

I am often asked "What inspires you?" and "When you have a creative block, how do you unblock it?" The unhelpful answer to the first question is that I can be inspired by just about everything, both good and bad. But when you have a problem to solve—whether it's fixing a leak, keeping deer out of your yard, or trying to mend a broken relationship—your inspiration, your first clue about what to do, lies within an analysis of the problem itself. That's where the solution originates.

As for a creative block, my psychic Drano, so to speak, is my environment and the things and people in it. I am lucky enough to live and work in Manhattan, and when I'm stuck, I have only to walk two or three blocks in any direction and I'm instantly reminded of the resilience of humanity and our ability to create things in the face of massive indifference and mounting expense. You see examples of design that astound (MoMA, the Chrysler Building, Central Park), some that are a disaster (subway passages that are too small to handle commuter crowds, taxi off-duty lights, poorly demarked sidewalks suddenly closed for construction), and everything in between.

But you don't need to be a New Yorker or a designer to appreciate how things are created and how they function in the world. You just have to be interested. And yes, you have to judge, often based on a first impression. Why not learn how to do it better?

I am going to show you some examples of objects and places that form my ideas about design and how it can work, or not. I encounter them in my life every day, and have taken all the following pictures myself.

Let's start with one that's very simple and often overlooked:

Help me organize my life, please.

If you work in publishing, you will have discovered binder clips very quickly. They hold literally everything together, from manuscripts to page proofs, and I've found them to be an invaluable organizational tool.

For those of you who don't work in publishing, I urge you to get some binder clips regardless. The simplicity and elegance of these devices is utterly transparent, as opposed to, say, digital folders within folders within folders. And the handles of the clip can be collapsed down so that they lie flat.

Whenever I go on a trip (once a month on average), I print out all applicable documents—boarding passes, itineraries, hotel reservation codes, rental car papers, etc.—and collect them in a single bundle with a color-coded binder clip. I drop the bundle in my tote bag (with the clip visible at the top—this is very important) and I'm off. When I need the documents, they can be located immediately by the bright hue of the clip.

As for storing all this stuff on your phone, news flash: your phone can die. Paper does not die, because it's already dead and resurrected.

I remember being caught in a security line at JFK behind a gentleman (ahem) who was trying in vain to revive his smartphone to show his boarding pass, to no avail. There were tears.

First impression: Squeeze, clamp, release. Organized.

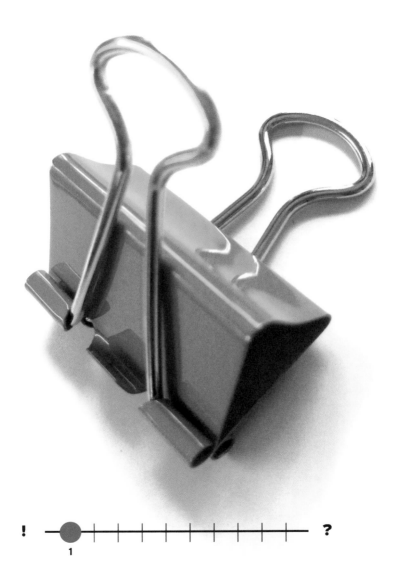

Nice package.

As long as there are consumer goods, there will always be physical packaging. But just because something is meant to be paid for and consumed does not mean its design has to be cloying, condescending, or screaming for your attention.

The Mrs. Meyer's cleaning products are a great recent example of how this can be done distinctively and successfully. The typography is so, well, clean. The red circle with the white interior is strategically placed in the center of the label, clearly telling you what it smells like. The product itself is biodegradable and isn't tested on animals. The bottles are recyclable.

Also eye-catching and yet beautifully understated are the vessels for Good's Potato Chips. I was born and raised in southeastern Pennsylvania, and these chips were a staple of my childhood. To this day they're only distributed locally. You can get them in a two-pound cardboard box (opposite, right), but when I was a kid they used to come in big tin cans (opposite, left), which we could either return for a refill or keep for reuse. But we never threw them away. The design scheme has remained unchanged since the company was founded in 1886. Red containers are for "Homestyle" (lighter, crispier chips), and blue containers are for "Kettle Cooked" (thicker, crunchier chips).

Oh, and they're incredibly delicious because they're cooked in LARD. Oh, yes. *Burp!*

First impression: I can identify these products immediately, and high quality will make me a loyal customer.

1

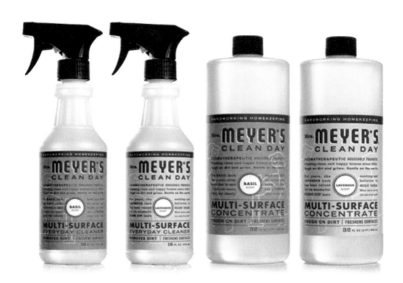

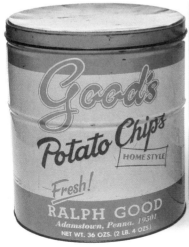

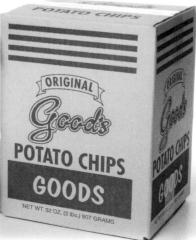

Use only as directed . . .
but for what?

And then there is *this* kind of packaging, for prescription medication, which baffles me. Why is it that over-the-counter medicinal packaging tells you exactly what it's for, while prescribed products do not? For example, Lamisol proudly declares that it "Kills Athlete's Foot," while my prescribed luliconazole cream, used to treat the same thing, says nothing of the kind. I asked a friend of mine in the pharmaceutical business about this, and while he didn't have a definitive answer, he did come up with a two-part theory. First, the drug industry assumes that if you are prescribed a treatment by a doctor, he or she will tell you what it's for, so the label doesn't have to. Second, the *real* story is that it's (surprise, surprise) . . . a legal issue, and has to do with diagnoses far more dire than foot fungus. Not long ago, drug giant Eli Lilly was sued because a doctor prescribed one of its products for depression when it was really meant to treat schizophrenia. It did not end well, either for the patient or the company. Such is the potential danger of mystery and interpretation.

So what's the answer? Sharpies! They write on *anything*. I can scrawl directly on tubes and pill-bottle tops in black or red ink and take away the guessing.

First impression: I need to know what a product is for, right away, just by looking at it. *Especially* medicine.

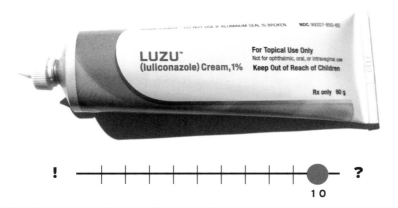

LUZU (luliconazole) Cream, 1% for topical use
Initial U.S. Approval: 2013

-----------------------------------INDICATIONS AND USAGE-----------------------------------
LUZU (luliconazole) Cream, 1% is an azole antifungal indicated for the topical treatment of
interdigital tinea pedis, tinea cruris, and tinea corporis caused by the organisms *Trichophyton
rubrum* and *Epidermophyton floccosum,* in patients 18 years of age and older. (1)

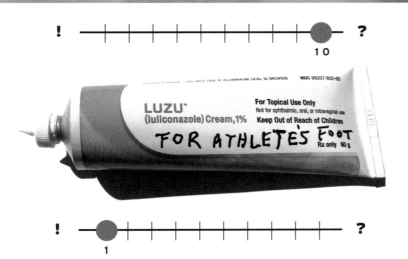

Bite.

When I heard that one of my graphic-design heroes, Peter Saville—the legendary designer for Manchester, England, label Factory Records (whose recording artists included Joy Division and New Order)—was going to redesign the iconic Lacoste crocodile (below), I was as surprised as I was delighted. Here were two of my favorite worlds—preppy clothes and post-punk music—colliding unexpectedly and deleriously head-on.

The original logo was created in the 1920s by French tennis star René Lacoste, nicknamed "The Crocodile" for his tenacity on the court. For its 2013 limited edition of the shirt, the Lacoste label hired Saville to reinterperet it, and he did so with inspired fervor. He generated eighty variations in all (opposite), commemorating the eightieth anniversary of the company. These abstractions are recognizable because we know both the source material and the context: over the heart on a white cotton polo shirt.

First impression of the original logo: Cool metaphor.
First impression of Saville's variations: Even cooler.

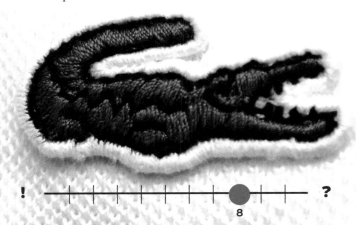

! | | | | | | | | ?
8

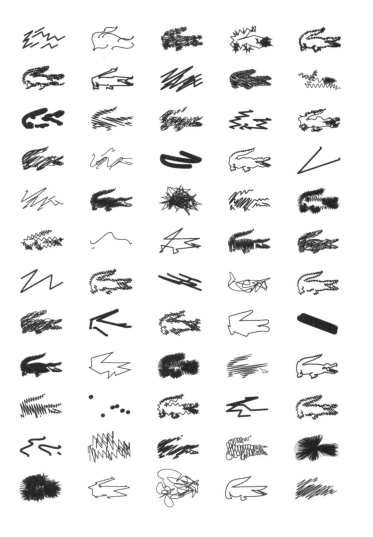

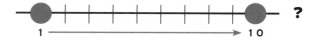

Block that billing!

It always seems strange to me that movie poster credits (or the billing block, as it's known in the business) appear in those extremely condensed, skinny typefaces that are so hard to read. The reason for this has to do with film industry guidelines and a typographic technicality determined by the logo of the film on the poster. Type (or font) height is measured in units called points (this text you're reading right now is 11 points, for example). Type width is not actually numerically measured at all, but is classified by "weight"—light, bold, extra bold, heavy, etc.

So, by most Hollywood labor union standards, the point size of the billing block has to be at least 25 to 35 percent of the point size of the title of the movie. Using an ultracondensed typeface allows the height of the characters to meet contractual obligations while still providing enough horizontal space to include all the required text.

And render it nearly indecipherable.

The image opposite was scanned in at actual size from an ad in the *New York Times*, and in addition to the fact that the printing is terrible (see "CMYK," page 90), the most important incidental information seems to be that it will be released on September 12 and is rated R. I think the creators should be better credited.

And by the way——as someone who sets type all the time for a living, I can tell you that using a smaller point size with a heavier width for billing blocks would be much easier to read and fit the space just fine. Like this.

First impression: Who made it?

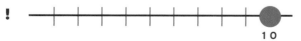
10

Hot impression.

Manufactured by the Pyrex/Corning Glass corporation in 1945 as an attempt to save metal for the war effort, the so-called Silver Streak glass iron's beauty is matched only by its utter impracticality. It appears to embody a total contradiction of purposes, like a toaster made out of ice. And yet the result is a marvel of industrial engineering that has a reason for being beyond aesthetics, which is why I find it so inspiring—it's a mundane household appliance transformed into a work of art. It was originally available in five colors: red, blue, green, silver, and gold, and was in production for only one year. Collectors trip over themselves to get one, or do whatever the Internet equivalent of tripping over oneself is.

First impression: Familiar function, surprising form. The ordinary can be made extraordinary.

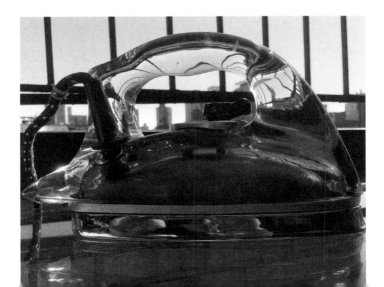

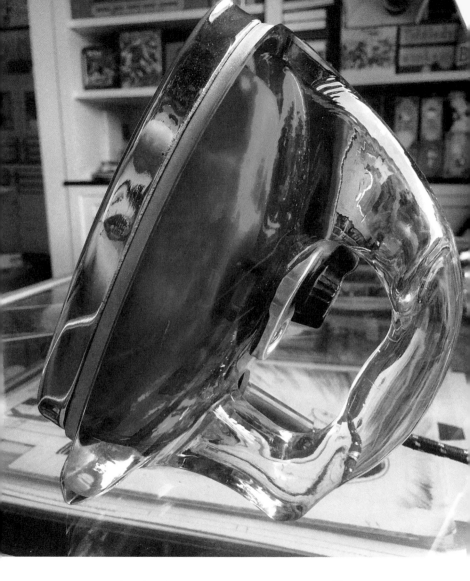

Call Security!

Of course security in Manhattan office buildings is extremely important, but what never ceases to amaze me are the instant ID tags they make for you in the lobbies of some corporations when you come to visit—in this case (opposite), DC Comics. They have a little camera mounted on the reception desk, and the person behind it takes your picture and prints out a paper ID card (full disclosure: the same thing happens at the TED offices in downtown New York City), which you use to get through the turnstiles and into the elevators.

Fine. What I take issue with is the photo. I mean, that's actually me, but it could be anybody. What's the point? They've already looked at my driver's license, and I'm logged into the visitors' list; shouldn't this technology be a little more advanced by now? Oh well, just call me the Phantom Stranger (comic-book geek joke; look it up).

First impression: If even I can't recognize myself, how is security supposed to? Are print-on-demand ID cards really still in their infancy?

1700 Broadway

Visitor:

Chip Kidd

06/30/2014
3rd Floor

Visiting: Daniel Didio
Warner Bros.

! —+——+——+——+——+——+——+——+——+——●— ?
10

So cool.

Just when you're ready to give up on the human race in general, along comes the Ice Bucket Challenge, and you believe again.

And then all your friends and Superman and Lois Lane do it, too (opposite), and you donate money.

I realize that by the time this sees print the Ice Bucket Challenge may be yesterday's news, but it's worth noting here anyway, because this is how to spread a message using a great idea—remember: polio was once yesterday's news, too. The origins of the practice of dumping cold water on one's head to raise money for charity are unclear and have been attributed to multiple sources (mostly televised football games), but this initiative, started in 2014, has raised well over $300 million to date to fund research in the fight against amyotrophic lateral sclerosis (aka ALS, or Lou Gehrig's disease), for which there is as yet no effective treatment or cure.

The idea is simple, direct, and tailor-made for the age of viral video, and emphasizes perpetuation. Perhaps most important, it connected with the public at large, who otherwise might not have been aware of the cause and were all too willing to dump freezing-cold water over their heads so they could empathize with people less fortunate than themselves.

The message took hold. We don't need to see cats riding vacuum cleaners anymore; we need to do something about a dire problem, and have some fun in the process—and pay our good fortune forward.

First impression: This is how to design a fund-raiser.

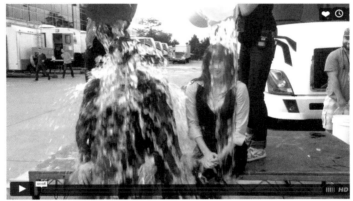

ALS Ice Bucket Challenge - Amy Adams & Henry Cavill

from **Cruel Films** PLUS 6 days ago

27

! ————————●———————— ?

4

Fully adjustable.

You may or may not be familiar with this side table, but the designer, Eileen Gray (1878–1976), deserves to be a household name. She is my go-to design hero for furniture and interiors, and she came to prominence after her death. Gray befriended contemporaries like Le Corbusier and Marcel Breuer, and her work was inspired by the Bauhaus, but I think she transcended that movement with just the right amount of quirk.

She was recognized by clients and the design cognoscenti of her milieu, but none of her creations were mass-produced in her lifetime, which is tragic, and she faded into obscurity after World War II. But interest in her achievements was revived in 1972 by fashion designer Yves St. Laurent, who bought some of her work at auction. In 2009, Gray's "Dragons" armchair prototype (ca. 1919) sold for more than $28 million, setting a record for twentieth-century furniture that has yet to be surpassed.

The E1027 table (opposite), named after the seaside house she built in the south of France with her partner, Jean Badovici, is beautiful, functional, and affordable. This faithful reproduction is widely available now for around $99. It looks great, but the point is that it derives its form from its function: you can slide the base under your bed so that the glass top floats over your lap. The height can be adjusted via the attached key and notched chrome stem.

First impression: To quote the early-twentieth-century monologist Ruth Draper: "It's chrome and glass and steel. It's adorable."

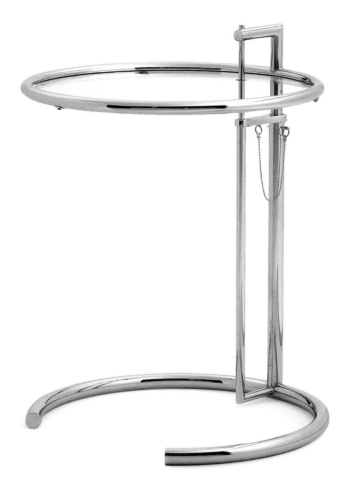

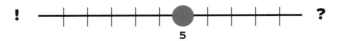

! 5 ?

Expect delays.

This notice of a change (opposite) in New York subway service—printed on an 8½" x 11" sheet of paper and taped to a girder on the platform, ahem—isn't terrible, but it's not as clear as it could be, either. And it really needs to be clear. What they're doing here is compartmentalizing information, which sometimes works and sometimes doesn't. I'd say this is one of the times it doesn't.

On the next spread I've reworked the sign to be clearer, using the same language, proportions, and colors available.

First impression: What is happening, exactly, and when?

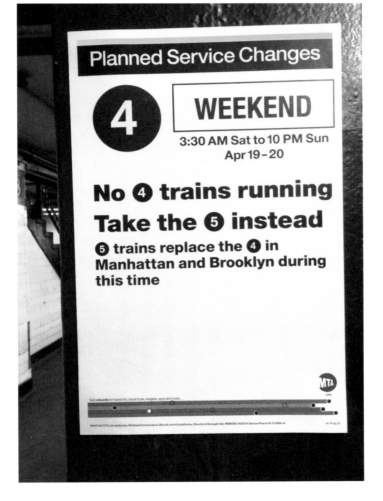

8

I have found that in cases like this, what is wanted is simple declarative sentences with a beginning, middle, and end, and which tell you directly what's going on.

What we see first (opposite) is that there's a service change (it doesn't matter whether it's "planned" or not), and then we see when it is happening and which train lines are affected. We keep the green circles around the white numbers, because that's how many people identify that particular train ("Just take the green line to City Hall, and then . . .").

It's also very important to include the Metropolitan Transportation Authority logo (which I think is great, by the way, because it implies forward movement) so that we know this is legit.

First impression: I will be taking the 5 train this weekend instead of the 4. On Monday it will be back to normal.

SERVICE CHANGE

THIS WEEKEND, APRIL 19-20

(3:30 AM SAT TO 10:00 PM SUN),

NO **4** TRAINS WILL BE RUNNING. TAKE THE **5** TRAIN INSTEAD.

5 TRAINS
REPLACE **4** TRAINS
IN MANHATTAN
AND BROOKLYN
DURING THIS TIME.

Counting down . . .

I am a habitually fast walker (because I'm always late, but that's another story), so when these crossing signals with countdown clocks started to appear at some Midtown Manhattan intersections in 2010, I was thrilled. They take all the guesswork out of deciding whether to try to beat the light or cool your heels at the curb.

It's not that the old system was bad, but this change makes a huge difference. Basically, when you see the white-lit walking figure (not pictured), it's okay to cross. Then, a red-lit hand appears next to the number twenty, which then counts down to zero (previously, there were no numbers). So, the image opposite (taken outside my apartment building) means that you now have twelve seconds left (and counting) to cross the street before you get run over. Or, stay put and wait for the walking man again. That's the kind of clarity I need.

Of course, *real* New Yorkers know that even when the countdown runs out you still have about five seconds to get across, but I probably shouldn't say that. Also, the "rule of physics" traffic law *always* applies to crossing the streets of New York City—that is, if there are no cars coming, go for it, regardless of what the light indicates. I shouldn't say that, either.

First impression: Twelve seconds to cross the street? An eternity. I can do that.

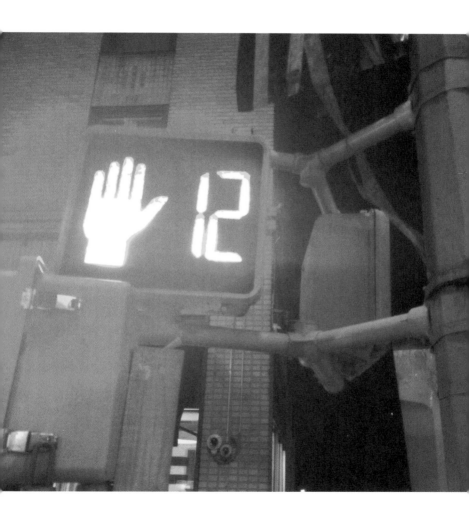

X marks the teeny, tiny, hard-to-find spot.

Don't you just love pop-up ads? Me, neither. And why would anyone, except adveed to rethink this, as far as I'm conce ne ugly, intrusive, insulting, trying to don't need or just flat-out lying, and to get rid of. Most have a tiny *x* in the that upon clicking will make them dis get at especially on a smartphone. All t gry at the sponsors and the websites th er use them to buy anything.

But if effective ves its goal, then I grudgingly have to e effective and have achieved it, but the pissing people off. What kind of goal as meant for better than this.

First impression: Intrusive design, diabolical purpose.

36

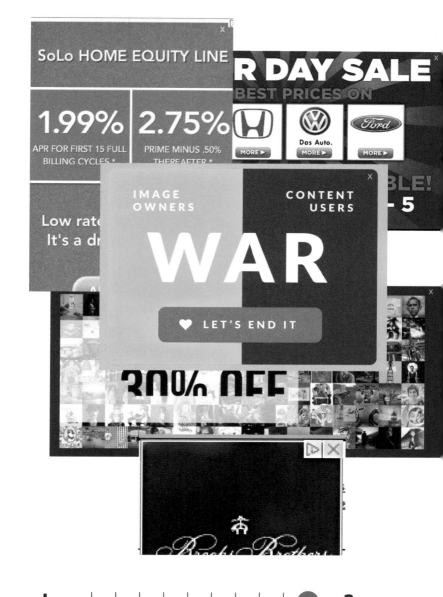

Picking up.

Even if I wasn't a Japanophile, I would still use chopsticks all the time, for all kinds of cuisine. Especially salads, which can be unwieldy on a fork. The cultural difference between selecting your food and stabbing it is symbolic of the quiet simplicity of the East versus the blunt directness of the West.

Chopsticks are a little tricky to master at first, but once you do, it can eventually seem a bit crude that you used to poke and prod at your meal with forks and knives. And chopsticks are great for noodle soups with ramen or udon, which spoons don't handle well.

This particular pair (opposite)—which I use to eat lunch at my desk—is made of resin, and thus is very washable and reusable, and doesn't absorb oils or other residue.

First impression: An elegant way to eat.

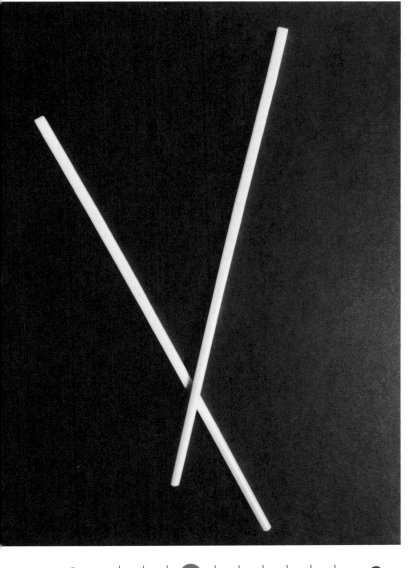

! ━━┼┼┼┼●┼┼┼┼┼━ ?
4

Don't get me started. Or do.

Now here is a mystery we just don't need, though it's one we have to face annually. Those of us who can afford to pay others to deal with it do so, and then deduct our accountant's fees from our incomes. That's more than a little crazy.

What makes taxes so maddening is the byzantine labyrinth of what's deductible and what isn't, and the fear that if you don't get the returns right, you will be audited. It's as though they're rigged from the start for you to fail, so you pay more than you need to just to be safe.

My first relationship was with a lovely Swiss fellow who was a banker, and he remarked that he didn't understand why the US tax system had to be so complicated.

"In Switzerland, they send us a tax bill that says how much we owe, and then we pay it. End of story."

That sounds so damned civilized.

First impression: You guys already know everything; can't you just tell me how much I owe?

Form 1040 Department of the Treasury—Internal Revenue Service (99)
U.S. Individual Income Tax Return **2013** OMB No. 1545-0074 | IRS Use Only—Do not write or staple in this space.

For the year Jan. 1–Dec. 31, 2013, or other tax year beginning , 2013, ending , 20 | See separate instructions.

| Your first name and initial | Last name | | Your social security number |
| If a joint return, spouse's first name and initial | Last name | | Spouse's social security number |

Home address (number and street). If you have a P.O. box, see instructions. | Apt. no. | ▲ Make sure the SSN(s) above and on line 6c are correct.

City, town or post office, state, and ZIP code. If you have a foreign address, also complete spaces below (see instructions).

Presidential Election Campaign
Check here if you, or your spouse if filing jointly, want $3 to go to this fund. Checking a box below will not change your tax or refund. ☐ You ☐ Spouse

Foreign country name | Foreign province/state/county | Foreign postal code

Filing Status
Check only one box.

1. ☐ Single
2. ☐ Married filing jointly (even if only one had income)
3. ☐ Married filing separately. Enter spouse's SSN above and full name here. ▶
4. ☐ Head of household (with qualifying person). (See instructions.) If the qualifying person is a child but not your dependent, enter this child's name here. ▶
5. ☐ Qualifying widow(er) with dependent child

Exemptions

6a. ☐ Yourself. If someone can claim you as a dependent, do not check box 6a . . .
b. ☐ Spouse .

| c. Dependents: | | (2) Dependent's social security number | (3) Dependent's relationship to you | (4) ✓ if child under age 17 qualifying for child tax credit (see instructions) |
| (1) First name | Last name | | | |

If more than four dependents, see instructions and check here ▶ ☐

d. Total number of exemptions claimed

Boxes checked on 6a and 6b
No. of children on 6c who:
• lived with you
• did not live with you due to divorce or separation (see instructions)
Dependents on 6c not entered above
Add numbers on lines above ▶

Income

Attach Form(s) W-2 here. Also attach Forms W-2G and 1099-R if tax was withheld.

If you did not get a W-2, see instructions.

7	Wages, salaries, tips, etc. Attach Form(s) W-2	7				
8a	Taxable interest. Attach Schedule B if required	8a				
b	Tax-exempt interest. Do not include on line 8a . . .	8b				
9a	Ordinary dividends. Attach Schedule B if required	9a				
b	Qualified dividends	9b				
10	Taxable refunds, credits, or offsets of state and local income taxes . . .	10				
11	Alimony received	11				
12	Business income or (loss). Attach Schedule C or C-EZ	12				
13	Capital gain or (loss). Attach Schedule D if required. If not required, check here ▶ ☐	13				
14	Other gains or (losses). Attach Form 4797	14				
15a	IRA distributions .	15a		b Taxable amount . . .	15b	
16a	Pensions and annuities	16a		b Taxable amount . . .	16b	
17	Rental real estate, royalties, partnerships, S corporations, trusts, etc. Attach Schedule E	17				
18	Farm income or (loss). Attach Schedule F	18				
19	Unemployment compensation	19				
20a	Social security benefits	20a		b Taxable amount . . .	20b	
21	Other income. List type and amount	21				
22	Combine the amounts in the far right column for lines 7 through 21. This is your **total income** ▶	22				

Adjusted Gross Income

23	Educator expenses	23	
24	Certain business expenses of reservists, performing artists, and fee-basis government officials. Attach Form 2106 or 2106-EZ	24	
25	Health savings account deduction. Attach Form 8889 . .	25	
26	Moving expenses. Attach Form 3903	26	
27	Deductible part of self-employment tax. Attach Schedule SE .	27	
28	Self-employed SEP, SIMPLE, and qualified plans . .	28	
29	Self-employed health insurance deduction . .	29	
30	Penalty on early withdrawal of savings	30	
31a	Alimony paid b Recipient's SSN ▶	31a	
32	IRA deduction	32	
33	Student loan interest deduction	33	
34	Tuition and fees. Attach Form 8917	34	
35	Domestic production activities deduction. Attach Form 8903	35	
36	Add lines 23 through 35	36	
37	Subtract line 36 from line 22. This is your **adjusted gross income** ▶	37	

For Disclosure, Privacy Act, and Paperwork Reduction Act Notice, see separate instructions. Cat. No. 11320B | Form **1040** (2013)

Where the toys are.

I love saving the heroes.

Ever since I can remember, I wanted to live in a comic-book museum when I grew up. I think I've pretty much achieved that. I've been collecting toys all my life, mostly of the vintage superhero variety; opposite is a photo of a wall in my apartment. I look at the toys every day, and what really inspires me beyond my fandom (which is huge, obviously) are the colors—the saturation and combination of the primaries: red, blue, and yellow (plus green, as in Lantern and Arrow). In a lot of my book-jacket designs I use variations on the primary colors, and I suspect this is why.

When you take the colors away from the costumes—as they have in the Batman movies since 1989, for example—it very much changes your perception of the characters. When Batman is all in black, it's not that it's not fun anymore, but it's a very different kind of fun. Ditto the X-Men. We seem to take them more seriously, which is kind of ridiculous and yet a fan's dream at the same time. Everything opposite is from 1966 or earlier, and includes a lot of toys from Japan. (I love the the pop-cultural cross-pollination.) The preservationist in me gets a charge out of the fact that none of this was meant to be saved in the package. These were created before toy collecting became a thing; they were meant to be consumed and ripped apart. They were never supposed to survive like this.

First impression: The basic is heroic.

! —+——●——+——+——+——+——+——+——+— ?

2

Lead us not into Penn Station.

Certainly one of the most egregious New York design crimes of the last century was the destruction of the original Pennsylvania Station in 1962, and its replacement with the abysmal drop-ceilinged, overhead-fluorescent-lit, basement-level hell-pit under Madison Square Garden that remains today. It still somehow functions as the most-used transit hub in the United States, with more than 600,000 travelers moving in and out each day, at the rate of 1,000 people every 90 seconds. And yet it's an embarrassment of confusion and squalor, especially for a city that claims the mantle of Capital of the World (and yes, I use Penn Station all the time; I have to—I'm always on Amtrak).

In what appears to be a cruel joke, there are photos mounted on the gate pillars showing how spectacular the original vaulted Beaux Arts building used to be (opposite, bottom). Thanks a lot. But the mystery here is not only why it is so ugly, but how difficult it is to navigate through.

First impression: Airless, scuzzy, inefficient. A terrible introduction for visitors to New York City.

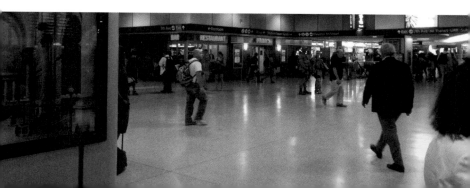

45

! |—+—+—+—+—+—+—+—●— ?
10

46

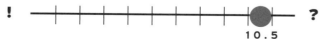

10.5

How refreshing.

This redesign of the Diet Coke can (opposite) is mysterious in the best possible way. Besides being formally striking, it assumes a level of intelligence and sophistication in its audience that is truly commendable, drawing on the "Less Is More" principles espoused by the architect Ludwig Mies van der Rohe. The visual vocabulary of the brand is reduced to its most essential parts, and we understand immediately what we're looking at, based on very little verbal information.

This is made possible by our decades-long familiarity with the logotype of the product and its application to a soda can. It's a cherished friend in fabulous new clothes, a BFF's makeover that you thought never could or would happen.

Truly great packaging.

First impression: Instantly recognizable; I don't even need to be able to read it. Thank you for trusting me.

Which makes the following advertising campaign all the more perplexing. Imagine that you are in the busy hub of the Times Square subway station, hurrying to catch your train, and you see this:

YOU MOVED TO NEW YORK WITH AN MBA, ONE CLEAN SUIT AND AN EXTREMELY FIRM HANDSHAKE.

YOU'RE ON.

! —|—●—|—|—|—|—|—|—|—|—|— ?

1.5

Um . . .

The mystery here is not *what* are they saying, but *why* are they saying it?

These Diet Coke ads were, in contrast to the packaging, clear in the *worst* possible way. I would guess that whoever is responsible for this thought they were being naughty and cool, but as someone who has done design work for Coca-Cola in the past, I am baffled and amazed that this ever saw the light of day. Nothing like this can happen without a LOT of important people signing off on it.

And, to clarify, that is *not* a period after "YOU'RE ON"; it's a trademark symbol. Nice.

Excuse me—
I'm on *what?*

! ⬤━┼━┼━┼━┼━┼━┼━┼━ ?
1.5

Call me crazy, but if you're a corporation with the global reach and customer base of Coca-Cola, isn't it in your best interests to *not* liken the consumption of one of your most popular products to something as dangerous and potentially devastating as abusing illegal narcotics—to say nothing of your responsibilities to your consumers? Why did someone in a high place (sorry) think that this was a good idea? How do these decisions get made? The focus testing alone (which normally I hate) should have sealed these ads' fate, but it didn't.

Ironically, it was the public at large's reaction that killed the campaign. It was pulled in a matter of weeks, due to mass pushback via parodies of the ads that were tweeted and posted on YouTube.

And NO, I am NOT on coke. But I suspect there is an advertising executive somewhere who is. Ahem.

Now we'll move on to how additional everyday phenomena can influence things I actually have to make.

Let's look at . . .

Judgment at work.

Okay, let's put our judgment to work. Here are some more examples of images and objects I see every day, but now I'll show how I've applied them to solving design problems in my working life (mostly involving book covers).

I've found it important to be constantly alive to the possibilities in my environment; that way, everything becomes fodder for ideas.

You never know when something might be useful, even if it's you . . .

Good morning.

I look at my tongue in the mirror every morning, and if it's not black, I'm good to go. If it *is* black, it usually means I had red wine the night before, and I brush it thoroughly. If I didn't have red wine, I call the doctor.

But seriously, a good look at your face in the morning can tell you all kinds of things: about your health, your mood, and how you will appear to everyone you meet for the rest of the day. Adjust accordingly.

You don't have to be a narcissist—you just have to pay a little attention.

First impression: There's a reason that your doctor tells you to say "Ahh." Learn what looking at your tongue can teach you about your well-being.

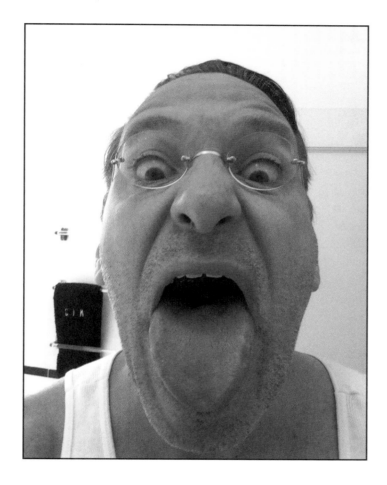

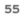55

Anyway, these sorts of things—mouths, health, and how we take in sustenance—were foremost on my mind when I was working on the cover of Mary Roach's book *Gulp*, her delightful and brilliant study of the human digestive system. The question was how to depict this and serve both the serious science involved and the witty spirit in which it was delivered.

56

There were many ways I could have gone about it, but the main thing I took away from reading the text was, how do I make the way the body digests food look *fun*? When I found this wonderful stock illustration from the Alamy agency, I knew it was perfect. Actual open mouths, as you have just seen, can be very off-putting in photographs. The witty spirit of this drawing gets us into the subject without putting us off.

In the end, I decided to start at the *beginning* of the digestive process, not . . . the end. Gulp.

Mary Roach

best-selling author of *Stiff*

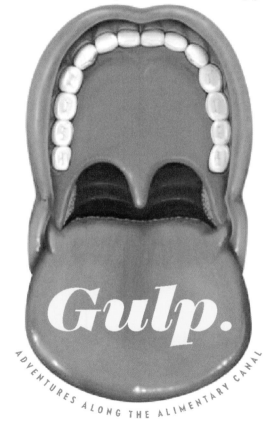

Gulp.

ADVENTURES ALONG THE ALIMENTARY CANAL

Lather up.

They don't make things like they used to, especially when it comes to grooming products. I bought this 1940s-era single-blade razor at a flea market nearly twenty-five years ago. It sits on my bathroom shelf, and I use it regularly. I love the considerable heft of it, and how it feels in my hand: sturdy, strong, capable. Plus, there's a large spring in the core, so when you wind up the base and let go, it vibrates, combining the idea of an electric razor with the more effective practicality of a manual. Works great, looks beautiful.

First impression: Great industrial design is not disposable.

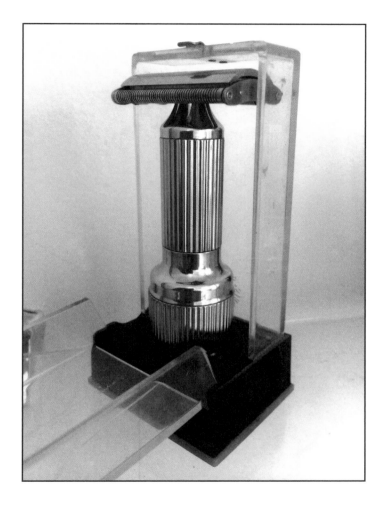

59

! 3 ?

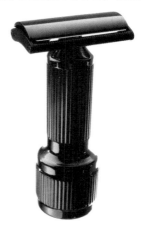

NICOLE KIDMAN
ROBERT DOWNEY JR.
FROM THE DIRECTOR OF *SECRETARY*

A FILM BY STEVEN SHAINBERG

F U R
AN IMAGINARY PORTRAIT
OF DIANE ARBUS

Film director Steven Shainberg asked me to create the teaser campaign for *Fur*, his truly kooky but fascinating biopic about the genius photographer Diane Arbus. The project was totally opposed by Arbus's estate, so none of her pictures could be used, either on the poster or in the movie itself. But Shainberg made the film anyway, with Nicole Kidman and Robert Downey Jr., in what has to be one of the least successful movies with an A-list cast in recent memory. In it, Downey plays a circus-freak wolfman-figure with a body totally covered in hair, and in a climactic scene Kidman's Arbus takes a razor (not unlike my vintage model) and shaves every square inch of it off. I thought the connection between the stark visual of the razor juxtaposed with the clipped verbal title would make an interesting tease (photos of the stars were used in the main campaign that followed this), while prominently featuring the names of the actors would assure viewers that this was a film to take notice of. Alas, not that many people did.

Get your balance.

Do you remember when you used to actually have to go to the bank teller to get money? Probably not.

Automated teller machines became popular in the late 1970s and were a revelation of convenience. But there were two problems: 1) they literally swallowed your bank card in order to read it, and sometimes didn't give it back; and 2) the keypad for entering your PIN was often conspicuously placed, giving cyber-pickpocketing Peeping Toms too much ammunition.

That has changed, for the better. This machine (opposite) near my office is typical of most, in that the card reader scans the card without making it disappear. The addition of touch-screens and security cameras (upper left) have made sidewalk banking not only safe but the norm. Headphone jacks for the hearing impaired and braille on the keys—followed by audio instructions for the blind—certainly help those who would otherwise be unable to use ATMs. Yes, banking apps for smartphones are great, but as long as we need cash (and we will always need cash; sorry, Bitcoin peeps and Apple Pay), these machines are the way to go.

First impression: I push a button and money comes out. It's like magic! And secure and safe—a beautiful thing.

THIS ATM OFFERS AUDIO
ASSISTANCE FOR THE
VISUALLY IMPAIRED.

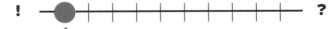

! 1 ?

Beth Kobliner (a dear friend) is sort of the Suze Orman for people who want straightforward personal financial planning information without a lot flash and fanfare, and she asked me to do the cover for her book about money management for young people. An ATM receipt definitely seemed to be the answer. But what you're seeing instead of your bank balance is what you should be doing *with* it.

This is called appropriating the visual vernacular, which means using a visual trope or conceit having to do with one kind of information and applying it to another. See also *The Mind's Eye*, page 80, and *Brazzaville Beach*, page 96.

THE NEW YORK TIMES BESTSELLER

GET A FINANCIAL LIFE

PERSONAL FINANCE
IN YOUR TWENTIES
AND THIRTIES

GET OUT OF DEBT................
..........AFFORD A HOME OF YOUR OWN
INVEST WISELY WITH LITTLE MONEY..........
...........IMPROVE YOUR CREDIT SCORE
PAY LESS IN TAXES.....................

BETH KOBLINER

How much?

The clarity of the design of the dollar bill has been consistently effective for more than one hundred and fifty years, no matter how it has varied: the image of George Washington is just perfect as the representation of the birth of the United States and its currency: he can be trusted, relied on, and believed in (he can't tell a lie!).

The two green tones (soothing, reassuring, earthy), the precise engraving and stamping, the texture of the resilient cotton and linen paper in the hand that can withstand countless transactions—this is great graphic design that hundreds of millions of people interact with every day.

First impression: In this we trust.

! 1 ?

Larry Kramer's searing fictional revisionist history of the United States includes a panoply of well-known figures, including George Washington, Abraham Lincoln, Malcolm X, Martin Luther King Jr., and many more. I chose to start at the beginning, with Washington, and take a detail of a famous portrait of him from 1796 by Gilbert Stuart. I was definitely influenced by the dollar bill, but I thought that by actually using that, this would look too much like a book about finance, which it definitely is not.

Even though the close-up is extreme, we know Washington's face so well that, coupled with the book's title, the viewer can easily put two and two together: this is going to be a new point of view on the American Story. The boldness and modernity of the typeface (Blender by Nik Thoenen) signals that this is a contemporary take on historical material.

THE
AMERICAN
PEOPLE

VOLUME 1:
SEARCH FOR
MY HEART

LARRY
KRAMER

! ?

9

Like five fingers.

When designing the cover of a book, one starts with the text and uses it as a guide to suggest visuals. In my case, since I mostly work on hardcover first editions, the text is usually in the form of an unedited manuscript. There is something about reading a book in its raw form that helps me really get into the head of the author; I feel like I am there at the creation of the work.

In Haruki Murakami's *Colorless Tsukuru Tazaki and His Years of Pilgrimage*, there was a particular phrase about a third of the way in that seemed to define what the jacket should be. The story itself is about the title character's sudden exile from his four very closest friends' circle, for no apparent reason, and his long journey back from the pit of despair this plunges him into. It takes years for him to heal from this, and then to gain the courage to confront his friends one by one to find out why they cast him out. In the meantime he becomes fascinated by the Tokyo transit system and eventually finds meaningful employment as an engineer designing train stations.

The first of the friends he tracks down is Ao, who now has a successful Lexus dealership in their hometown of Nagoya. He seems to have no animosity toward Tsukuru, and when they go to lunch and talk, he recalls the five friends in the manner you see underlined in red on the opposite page.

First impression: An image of a hand is the perfect metaphor to depict the closeness of this quintet.

ny role
ook. "I don't g
orless background.
of person was necessary.
"You're weren't empty. Nobo
the rest of us relax."

relax?" Tsukuru repeated, surprised. "Like e

ike that. It's hard to explain, but having you there, we
didn't say much, but you had your feet solidly planted on the
group a sense of security. Like an anchor. We saw that more clea
t with us anymore. How much we really needed you. I don't know if tha
out after you left, we all sort of went our separate ways."

Tsukuru remained silent, unable to find the right reply.

"You know, in a sense we were a perfect combination, the five of us. Like five
ingers." Ao raised his right hand and spread his thick fingers. "I still think that. The five
of us all naturally made up for what was lacking in the others, and totally shared our
better qualities. I doubt that sort of thing will ever happen again in our lives. It was a one
time occurrence. I have my own family now, and of course I love them. But truthfully
don't have the same spontaneous, pure feeling for them that I had for all of you bac
n."

Tsukuru was silent. Ao crushed the empty paper bag into a ball and roll
his large hand.

uru, I believe you," Ao said. "That you didn't do anything to
makes perfect sense. You'd never do something like th
was wondering how to respond, Viva Las Vegas!
cked the caller's name and stuffed the pho

PROJECT:

COLORLESS TSUKURU TAZAKI AND HIS YEARS
OF PILGRIMAGE
BY HARUKI MURAKAMI

A NOVEL ABOUT

FOUR CLOSE FRIENDS WHO CAST OUT A FIFTH

The image of a hand here is abstracted, and may not be clear at first. That is fine, because a major theme in the story is that Tsukuru's banishment is a total mystery to him. His four friends—two men, two women—have names that in Japanese correspond to colors: Mr. Red, Mr. Blue, Miss White, and Miss Black. Tsukuru's name has no such association, so he goes by Colorless. He is represented here as the "thumb" on the hand—a symbolic anchor that supports the others—and is represented by a detail of a Tokyo railway map, which just happens to use the colors of his friends.

Note that when Ao makes the reference to five fingers (page 71), he raises his right hand, so that determined which hand I should depict.

On the physical book, each of the five "fingers" is actually a die-cut window (literally, a hole punched out by the printer with a metal die) in the jacket itself, and when you remove it, the visual narrative on the cover/binding continues and leads to a new meaning.

This design is not meant to be immediately understood; the idea is to entice the reader to investigate the book in order to decode it. But the materials used—silver ink for the background, cellophane behind each finger-window—are very clearly intended to draw you in, in a way that an image on a screen (or even on the opposite page) cannot.

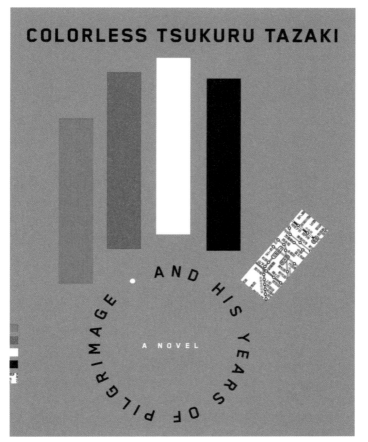

COLORLESS TSUKURU TAZAKI

AND HIS YEARS OF PILGRIMAGE

A NOVEL

HARUKI MURAKAMI

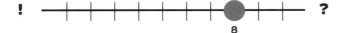

! 8 ?

I'll have . . .

I didn't know what carrot cake was until I came to New York and saw the thick and creamy slices under the city's famed delicatessen counters. I was dubious: making a cake out of carrots seemed about as good a plan as making ice cream out of zucchini (which someone, somewhere, has no doubt done by now—probably in Brooklyn).

And yet one bite proved it delicious, mainly because it was so bolstered by slabs of buttercream icing, sugar, and lots of spices that the carrots themselves really became a gastric afterthought.

But what really got me design-wise was the orange-and-green confectioner's decoration in the shape of a carrot on the top of each piece, to remind you of the "main" ingredient. This illusion—the implication that a product is good for you because it's made out of something that's good for you—has been used in advertising for years, for products such as Land O'Lakes butter, menthol cigarettes, Apple Jacks cereal, and raspberry Pop Tarts.

Caveat emptor.

First impression: It's got to be healthful—look at the little carrot on top of it!

! —————————●————————— **?**

5

And so I was faced with creating an image for former surgeon general David Kessler's book on how to deal with the rise of obesity in this country.

The original title was going to be *Sugar, Salt, Fat*, which would have been much, much easier to deal with, because it's very direct and would have contrasted brilliantly with images of anonymous overweight people from the, um, rear.

But then David decided he wanted the book to be not just about the problem of obesity but also what can be done to help solve it. Thus *The End of Overeating*.

Okay, fine, but how do you *show* that? Do you have people sitting at tables with empty plates in front of them, not eating? Such an image wouldn't get the point across. That's when I harkened back to the carrot cake and its origins. This scheme (opposite) can be perceived as Before and After, going from top to bottom: so you see the cake first, get scolded/informed, and then see what you really should be eating.

The book was number one on the *New York Times* bestseller list for several weeks, and Kessler remarked to me on more than one occasion afterward that it was because of the icing.

Fine, I thought; as long as you can only look at it.

The end of overeating.

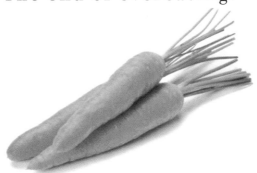

DAVID A. KESSLER, M. D.

! ——+——+——+——+——+——+——+——●——+—— ?

8.5

Can you read
the top line?

Eye charts—developed in the mid-nineteenth century by Dr. Franciscus Donders and his colleague Herman Snellen in the Netherlands—fascinate me because they are meant to be read, but not in any conventional sense (out loud, without conveying coherent meaning). They start out extremely clearly at the top, and then get more mysterious line by line, depending on your eyesight.

Form and content are completely divorced from each other here, because if the letters spelled out actual words, it would be easier to cheat at reading what they are. Most examples, like this one (opposite), use serifs on the letters—the extra lines on the ends—to render them harder to make out as they get smaller.

This is a simple, inexpensive, and low-tech solution that has become visually iconic and is still in use after one hundred and fifty years.

First impression: E! Now how low can I go?

So the famed neurologist and writer Oliver Sacks goes to the eye doctor for his annual checkup, and the letters on the eye chart start to do funny things. Thus begins his exploration of visual perception in the brain, along with an investigation into the cases of six other extraordinary people who have learned to cope with extreme and often potentially devastating changes in their vision.

The visual vernacular here of an eye chart was a no-brainer (sorry), but what makes this different is the letterforms going in and out of focus to mimic Sacks's experience. On a book cover, something like this has to be handled very carefully so that it remains readable.

And then there is the color. My original design was much more muted, skewing to the generally monochromatic nature of the source material, but Oliver wanted something livelier, because the stories are actually about overcoming adversity. He was right: the iconography of an eye chart is so recognizable that it can easily withstand being rendered in bright red and yellow.

And its calling attention to itself on the bookshelf didn't hurt, to say the least.

Say what? Say *that*.

As a resident of New York City over the past several decades, and one who creates visuals for a living, I have truly mixed feelings about graffiti. By definition it's a marring of public property, and if it goes unchecked around me, it makes me feel that anarchy has taken over. This is not a good thing, trust me (East Berlin, anyone?). Also, the messages are usually indecipherable and ultimately drown each other out.

Then there's a whole other kind of graffiti—which I see mostly on advertising posters in the subway—that sometimes really *does* have something to say, and to me is far more interesting. In this particular case (opposite), it is commentary on the apartment-sharing phenomenon of Airbnb (please note: I am not expressing my opinion of Airbnb, I am just commenting on someone else's viewpoint).

We are told clearly that this person is against this service, but it leads to questions as to why (bedbugs? Really?). Still, this is a strong statement that is communicated directly and plainly, and leaves the viewer with something to think about beyond what the sponsor intended.

Often these kinds of "annotations" are puerile and vulgar, but this one isn't. Someone really cares about the issue and wants to inform the public. It's now up to you to investigate it, if you want to, and draw your own conclusions.

First impression: Freedom of expression here is not limited to print advertisers by any means. Anyone with a Magic Marker and a reaction can chime in, too.

So for David Rakoff's book of essays, *Fraud*, I decided to apply this "annotation" concept as well.

Most of the pieces in this book involve assignments the urbanite author had taken that he was not qualified to do: white-water rafting down the Colorado River; climbing an icy mountain in cheap loafers; and, perhaps most memorably, impersonating Sigmund Freud in a Barneys department store window during the Christmas holiday season. All of these dubious forays add up to the conclusion that Rakoff was misrepresenting himself.

So my idea was that you've bought the new book by David Rakoff (no other typography on the jacket), and as you start to read you begin to suspect you've been hoodwinked: this guy isn't who he says he is. So out of frustration you take a big red Magic Marker and scribble "FRAUD" on the jacket. This implies a catharsis, and looks pretty good and spontaneous, too. In the printing process of this jacket, it was all too easy to mimic the subtle texture of an actual red squeaky pen.

It was fun to see rows of these on bookstore shelves, looking as if some nut had sneaked in after hours and scrawled all over them.

FRAUD

David Rakoff

Where am I?

Google Earth is truly a marvel as an exploration tool (and Superman-flight-simulator), but it has also caused some controversy regarding privacy rights: just how much surveillance should be at everyone's fingertips? This will be an ongoing conversation, of course, but I think what would truly change the game is if Google Earth enabled you to see everything going on in real time. And it doesn't: this most recent overhead shot of my apartment block (opposite, in the middle) is more than three years old. I know that because the progress on the decades-in-the-making Second Avenue subway line is much further along than what I see here (thank god!). So in that sense Google Earth is literally the world's largest still photograph of the planet, which makes it much more of a map resource than a spy tool. The key to keeping it relevant will lie in constantly updating it.

I like it when newscasters report on something going on in a place that I'm not geographically familiar with. The camera usually starts out in a wide angle, high above the outline of a country or state, and then starts to descend, picking up speed, and zoom—you're there, and have gotten specifically oriented to where the activity is in less than three seconds.

But what Google Earth does best, and quite beautifully, is lend perspective. Look at how small we are, how close we are to our neighbors, how intricately our surroundings are structured. This, of course, is more pronounced in highly populated areas. What are the implications?

First impression: I better understand my environment when I can look at it from a new angle.

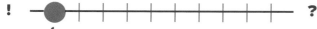

For the cover of Alan Ehrenhalt's study of the revitalization of urban environments, it seemed only natural to put Google Earth images to use (with permission, of course).

So opposite is Bushwick, Brooklyn, which is one of the author's case studies about the renewed desire to move from the suburbs back to cities and reclaim formerly desolate downtown areas.

But from this height, the photo could be of any of a host of places in America, and that serves Ehrenhalt's thesis that this phenomenon of reurbanization is happening all over the country. The gridded texture of city blocks simultaneously suggests the idea of complexity and order, two of the major themes of the book.

THE GREAT INVERSION

AND THE FUTURE OF THE AMERICAN CITY

ALAN EHRENHALT

CMYK

As a working print designer, I had to learn very early on about the offset lithography process (also called four-color printing) and how it works. Basically, all full-color images are composed of combinations of four components: cyan (blue), magenta (a pinkish red), yellow, and black (referred to by printers as K so as not be confused with blue). White is taken care of by the color of the paper itself. If you have a personal printer at home, then you know that there are four ink cartridges containing these colors inside, and the black one usually runs out first, because it's used in just about everything.

These colors are broken down into dot patterns called halftone screens, and when combined in the right ways, they can make just about any other color you can imagine (except fluorescents or metallics; they require their own special inks).

First impression: A brilliant system—from four simple building blocks, you can create millions of options.

YELLOW MAGENTA CYAN BLACK

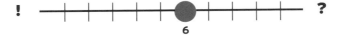

! 6 ?

Four-color printing has always been used to make comic books, and when the Abrams publishing house announced they were going to start a division that specialized in graphic novels (a fancy name for comic books), they asked me to create a logotype to give them a distinct visual identity.

The word "logo" is derived from the ancient Greek for "word," and refers to a graphic symbol that is used to identify and promote an organization (usually a commercial concern) or individual. The term "logotype" differs slightly from "logo" because it depicts the actual name of what it represents.

The solution for Abrams ComicArts was to be found in the components of the printing process itself. What do you see here?

The use of color enables the viewer to perceive this mark in four different ways: "Abrams ComicArts," "Abrams Art," "Comics," and "Art." Not unlike CMYK.

! +++++++++ ?

7

Smoked.

I have never smoked, but as much as I hate commercial tobacco, I do admit I admire many cigarette package designs because so many use what I call "separation of type and state," or the civilized division of typography and image. This is a separation (or distinction, if you will) that I make as someone who appreciates visual dichotomy: the aesthetic distance from what something looks like and what it represents.

This design (opposite) even holds up when it's crushed and stomped into the street, because the typography is classic, the colors are pure, and the proportions are balanced.

First impression: Filthy habit, clean design. Even when it's filthy.

PROJECT:
***BRAZZAVILLE BEACH* BY WILLIAM BOYD**
A NOVEL ABOUT A SCIENTIST IN AFRICA

In this story about a Jane Goodall–like researcher of primates in Africa, the main character smokes an obscure local brand of cigarettes called Tuskers. They don't actually exist, but other African brands certainly do, so I visited smoke shops around the neighborhood of the United Nations building in New York to see what the packaging of these brands looked like (this was before the Internet existed). I borrowed several elements from them to make this cover: warm colors, linear geometry, an airplane, retro lettering, and gold foil across the top. The small strip of mathematical symbols over the plane is a reference to the main character's husband's job as a numerical theoretician (which eventually drives him mad).

Even if the source material is not initially recognizable, I am hoping that it doesn't matter to the reader so long as it piques his or her interest.

BRAZZAVILLE
beach

A NOVEL

WILLIAM BOYD

A GOOD MAN IN AFRICA & AN ICE-CREAM WAR

! | | | | | | | | | ?

9

Have we Met?

Who needs Chippendale's when you can go to the Metropolitan Museum? I'm kidding! Sort of. Well, not really. But certainly the ancient Roman and Greek statuary galleries there contain some of the most extraordinary examples of stone carving in the world. And they are indeed sensual.

A sculptor friend of mine once put it succinctly: How do you make a block of marble look like it's actually breathing? The question is as simple and as complex as that, and the answer lies in techniques that I can't begin to understand but at which I endlessly marvel. That the artists usually choose to depict idealized physical specimens (gods, goddesses, nymphs, satyrs, etc.) only makes the end product all the more enticing. They were the supermodels of their day. Did anyone really want to see a statue depicting imperfection? Back then, what would be the point?

But then there are the fragments of the figures that didn't survive the ages, which leave us to imagine the rest of them. These elicit a different kind of fascination because of what's missing and our desire to fill in the blanks to complete them.

Would the Venus de Milo be nearly as interesting with her arms intact? I think most people would say no (and yes, I know that's the Louvre—just saying).

First impression: Looks like flesh, yet hard as a rock. How did they *do* that? What was the process?

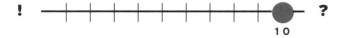

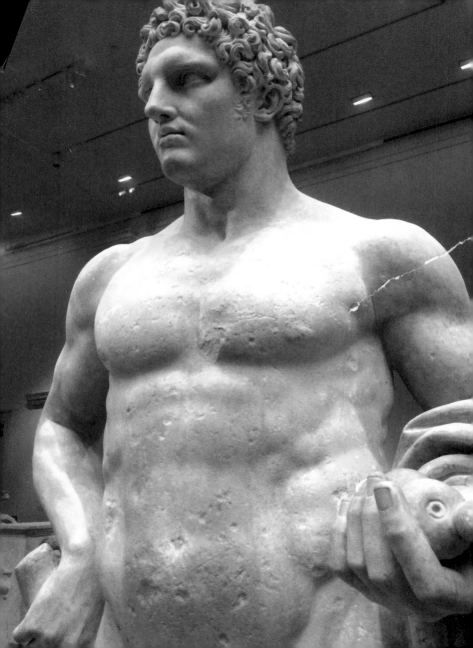

102

How do you encapsulate the idea of a contemporary (and, sadly, now deceased) historian and renowned art critic expounding upon one of the greatest ancient cities of the Western world? Well, I thought a statue fragment wouldn't be the worst way to go, especially given the special limitations on the front of the jacket (large, iconic title, ditto author name; not a lot of room left for the image). An entire head would have taken up too much space, and what's really important here is the idea of storytelling—oral tradition passed down from generation to generation.

So, talk to me, Professor Hughes. Tell me all about it.

ROME

A CULTURAL, VISUAL, AND PERSONAL HISTORY

ROBERT HUGHES

Jolly Roger.

I'm not sure when skulls and crossbones started to appear as a motif on clothing and accessories, but it's been happening for years now, and there's a timelessness to the symbol that is endearing, classic, and kind of horrifying, when you really think about it.

The skull-and-bones pirate flag originated in the 1700s and was flown on invading ships only when they came within firing range of the legitimate commercial vessels they sought to capture. The idea was to give their targets an opportunity to surrender without a fight. If they didn't, the black flags went down and were replaced with red ones—and all the implications that went along with them.

So the black pirate flags were, in the relative scheme of things, meant to be peaceful in a way: submit, and no one gets hurt.

That's a mantra, I'd say, that isn't at all irrelevant to the fashion business.

First impression: Yo ho ho and an embroidered belt!

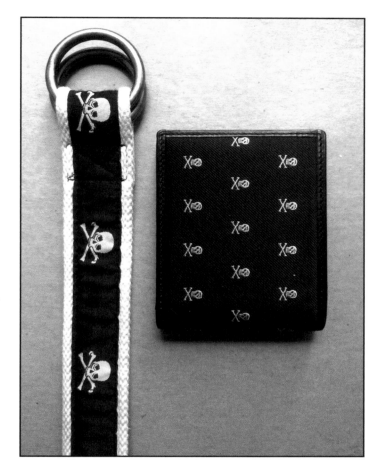

PROJECT:
VILLAIN
BY SHUICHI YOSHIDA
A NOVEL ABOUT A MURDER IN JAPAN

In photographer Francois Robert's Stop The Violence series, bones are ingeniously arrranged to create images of weaponry. "I use the human skeleton as the formal visual element, the subject of the image," he says. "In this manner, the skeleton is both the protagonist and antagonist (the Buddhist notion about "the duality of man"* seems apt). I intend the images to plant the notion of restraint and charity in an effort to promote peace and tolerance."

I had admired Robert's work for a long time, and when I received a manuscript for a novel called *Villain* by Shuichi Yoshida about the killing of a young woman in Japan, the two artistic sensibilities—of the photographer and the writer—seemed to go together.

This is a big part of what an art director does—gives form to a received piece of content. It's kind of like aesthetic matchmaking, pairing up the verbal with an arresting (so to speak, in this case) visual.

* Can be interpreted as the duality of one's state of consciousness and one's physical being. In Chinese philosophy this is the yin and the yang.

VILLAIN

A NOVEL

SHUICHI YOSHIDA

Good-bye.

I push this button (opposite) at the end of every workday in order to open the glass doors to the elevator vestibule on my floor of our office building so I can leave. The button is very clearly marked, but the mystery is why it exists in the first place. It's obviously another security measure, but what is it securing against? My leaving? Why?

There are red buttons to push all over New York City, usually in case of emergency: in elevators, on subway platforms, in street corner call boxes. But this isn't one of those; it's simply to open a door and let me out.

First impression: What is the danger here?

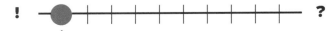

! 1 ?

The red button becomes something else entirely in this design for James Ellroy's book about what the events of December 7, 1941, mean to the City of Angels, and the way a horrific crime being investigated by detective/chemist Hideo Ashida of the LAPD somehow relates to all of it. The internment of his fellow Japanese-Americans in California at the dawn of the US involvement in World War II only exacerbates the tension, anxiety, and fear.

I tried to mimic that tension visually on this cover by pairing the graphically striking Japanese flag, the "rising sun," with the instantly recognizable nighttime grid of the streets of Los Angeles. This creates a visual standoff of light and dark, close-up and long view, bright and moody.

The idea here is that even if you don't know what "perfidia" means, you will want to find out.

JAMES ELLROY

PERFIDIA

A NOVEL

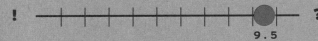

! —|—|—|—|—|—|—|—|—⬤— ?

9.5

Fender bender.

You never know what you'll see in the gutters of New York City, and when I came upon this (opposite) while walking to the subway one morning, I couldn't help but try to decode the story: a yellow taxi hit another car, or vice versa, and this was the residue. It was not as if I was at the scene of the accident—the source of it was long gone, or otherwise not in evidence.

But the conclusions to be drawn from the colors, the materials, the shattered bits, were undeniable. I've lived in the city long enough to know that insurance numbers were definitely exchanged.

Move along, people, nothing more to see here.

First impression: Small fragments can tell much larger stories.

! —+——+——+——+——+——+——+——+——+——+—— ?
8

HOW IT ENDED

BY JAY McINERNEY

SHORT STORIES ABOUT NEW YORK SOCIETY

Fiction writer Jay McInerney chronicles the high lives and low points of New York's demimonde, and a perfect source of imagery to illustrate this is brilliant society photographer Patrick McMullan. He took both of these pictures (opposite), and look how different they are: from the fashion-show runway excitement of the night before (top) to the sobering taxi-wreck reality of the morning after (bottom).

114

In contrasting these two sensibilities—night and day, happy and sad, delirious and slapped-to-attention—I tried to emphasize the wake-up call that the author brings to his readers.

And the pretty colors are nice, too.

Jay McInerney

NEW AND COLLECTED STORIES

HOW IT ENDED

What's going to happen next?

Well, that's one of the biggest mysteries of all, isn't it? Fortune cookies have been around for the past hundred years, and we hold out hope, after a Chinese meal, that they will tell us what to expect. Or at least we are entertained by them, spurred on to think about what they might mean. On the one hand, it's silly; on the other, it's possibly something to think about.

The design of the fortunes is a fascinating combination of simplicity and reduction that enlivens the theater of the mind and its infinite conjectures on the possibilities of fate. And all from one sentence on a tiny slip of paper!

And then, of course, there's interpretation: the fortunes are deliberately vague, so that we draw from our personal experiences in order to bring an explanation to them.

First impression: What does this mean, and how does it apply to me?

Hardly anyone knows how much is gained by ignoring the future.

! ——————————————— ?

13

This was the book that eventually became *When You Are Engulfed in Flames*, and it is the only jacket in this volume that didn't actually get produced. As sometimes happens in publishing, the author was weighing several different titles, and finally selected a different one.

Such a change also, of course, affects the cover design process and how I adapt my methods. The original title, *All the Beauty You Will Ever Need*, didn't directly apply to the content of any of the essays in the book, so in that sense I was free to think about an original context for the phrase. A Chinese fortune cookie seemed apt, as it provided a visual that I thought most everyone could recognize, yet had an attending sense of mystery. Note that the form of the slip of paper is so strong and recognizable that I didn't need to include cracked bits of cookie around it.

When the final title became what it is, I tried using it with the same design scheme, but it just didn't work—I think mainly because fortune cookies never tell you anything as shocking as the fact that you're on fire, right now.

David found a painting by van Gogh of a skeleton smoking, and that was great—the subject had already been through it all.

And so, yet again . . .

All the beauty you
will ever need.

david sedaris

author of the #1 New York Times bestseller
DRESS YOUR FAMILY IN CORDUROY AND DENIM

Clarity gets to the point.

I find that the older I get (I turned fifty during the making of this book), the clearer I want things to be. I think this is a natural symptom of maturation—as we age, mysteries pile up, and they're usually not the fun ones:

Just how long do I have?

Why do some people get what they deserve, and others don't?

Why are certain problems so easy to solve, while others are totally impossible?

Will they ever, ever bring working jetpacks to the marketplace?

Whoever you are, whatever you do for a living, you have problems to solve. I hope that this book has given you a little something to think about in terms of how you might proceed to do so. Ask yourself: What is this problem I'm trying to solve? How do I define it? What are its components? What is the goal I'm trying to achieve with its solution?

And remember . . .

Mystery gives us hope.

As we go on, Mystery becomes more important, too, because it helps us deal with things we can't understand.

It is fueled by faith: belief in ourselves, our friends, "the system," humanity in general, and whatever else it is we need to believe in. There's a reason we don't want great magic tricks explained.

Mystery is also valuable as a coping mechanism—the things that are all too clear are piling up, too:

Life is short.

Love can't be taken for granted.

Everything has a cost.

Just holding on to something doesn't mean it won't go away.

You can try to solve everything, but if you can't, that's okay. As long as you've tried your best.

And . . .

Always try to leave a good lasting impression.

So: what's clear to you?

And what isn't?

Those are not unimportant questions. Ditto these:

Are you clear to others when you need to be?

Do you understand how to use clarity and mystery, and when each is necessary?

Do you pay attention to how you are perceived by the world, no matter how big or small that world is?

Which brings us back to first impressions, a fitting way to end this little meditation. With this book, I've underscored the importance of healthy judgment. But I've also tried to introduce you to a few ideas (via my ideas, I am well aware) that might encourage you to look at things a little differently than you used to.

Did I succeed?

You be the judge . . .

Thank you:

Michelle Quint,

June Cohen,

Susan Lehman,

Gina Barnett,

Geoff Spear,

J. D. McClatchy,

Chee Pearlman,

David Rockwell,

Chris Anderson.

CHIP KIDD is a designer and writer living in New York City. His book cover designs for Alfred A. Knopf, where he has worked nonstop since 1986, have helped create a revolution in the art of American book packaging. He is the recipient of the National Design Award for Communication Design, as well as the Use of Photography in Design Award from the International Center of Photography. Kidd has published two novels, *The Cheese Monkeys* and *The Learners*. A distinguished and prolific lecturer, Kidd has spoken at Princeton, Yale, Harvard, RISD, and a zillion other places.

WATCH CHIP KIDD'S TED TALK

Chip Kidd's TED Talk, now available for free at TED.com, is the companion to *Judge This*.

JAMES DUNCAN DAVIDSON/TED

Yves Béhar: *Designing Objects That Tell Stories*

Designer Yves Béhar digs up his creative roots to discuss some of the iconic objects he's created (the Leaf lamp, the Jawbone headset). Then he turns to the witty, surprising, elegant objects he's working on now—including the $100 laptop.

John Hodgman: *Design, Explained*

 John Hodgman, comedian and resident expert, "explains" the design of three iconic modern objects.

John Maeda: *Designing Simplicity*

The MIT Media Lab's John Maeda lives at the intersection of technology and art, a place that can get very complicated. Here he talks about paring down to basics.

Stefan Sagmeister: *Happiness by Design*

Graphic designer Stefan Sagmeister takes the audience on a whimsical journey through moments of his life that made him happy—and notes how many of these moments have to do with good design.

TED Books are small books about big ideas. They're short enough to read in a single sitting, but long enough to delve deep into a topic. The wide-ranging series covers everything from architecture to business, space travel to love, and is perfect for anyone with a curious mind and an expansive love of learning.

Each TED Book is paired with a related TED Talk, available online at TED .com. The books pick up where the talks leave off. An 18-minute speech can plant a seed or spark the imagination, but many talks create a need to go deeper, to learn more, to tell a longer story. TED Books fill this need.

ALSO FROM TED BOOKS

The Future of Architecture in 100 Buildings
by Marc Kushner

We're entering a new age in architecture—one where we expect our buildings to deliver far more than just shelter. Filled with gorgeous imagery and witty insight, this book is an essential guide to the future being built around us—a future that matters more, and to more of us, than ever.

TED is a nonprofit devoted to spreading ideas, usually in the form of short, powerful talks (eighteen minutes or less). TED began in 1984 as a conference where Technology, Entertainment, and Design converged, and today covers almost all topics—from science to business to global issues—in more than one hundred languages. Meanwhile, independently run TEDx events help share ideas in communities around the world.

TED is a global community, welcoming people from every discipline and culture who seek a deeper understanding of the world. We believe passionately in the power of ideas to change attitudes, lives, and, ultimately, the world. On TED.com, we're building a clearinghouse of free knowledge from the world's most inspired thinkers—and a community of curious souls to engage with ideas and each other, both online and at TED and TEDx events around the world, all year long.

In fact, everything we do—from our TED Talks videos to the projects sparked by the TED Prize, from the global TEDx community to the TED-Ed lesson series—is driven by this goal: How can we best spread great ideas?

TED is owned by a nonprofit, nonpartisan foundation.